For my child, Lucia. Remind me again.

Note about the virtual imagery

The virtual landscapes in this book come from the mobile gaming app Pokémon GO®. Released originally by Niantic Labs in 2016, the augmented reality (AR) app uses location-based technology to reveal stripped-down virtual versions of the surrounding environment. Mack calls to attention the app's digital, barebones graphics that have come to substitute our greater reality, leading us to critically rethink our ever-deepening engagement with virtual technology. The flat, primitive renderings visually symbolize humanity's widening divorce from the essential depth of nature.

App Download

To experience this poetry book with the optional augmented reality app, please point your smartphone's camera at the QR code, and follow the on-screen instructions.

Foreword

by Richard Garriott de Cayeux

We are all explorers.

From the moment we are born, our senses capture everything we encounter and use this information to build our understanding of the reality in which we live. As a videogame developer, I believe that casting a wide net for inspiration is a big part of what helps make my work fresh and meaningful. My search for awe and wonder has literally taken me from pole to pole, traversing the entire earth; I have orbited above and looked down from the International Space Station and I have descended almost seven miles into the Pacific's Mariana Trench.

Our world is awesome.

I mean this in the truest sense of the word. Awe can be found everywhere—from the microscopic universe, to the tapestry of landscapes across Earth's surface, to the vista of our planet from space. As a creator of virtual worlds, I have sought moments of awe. At their best, these moments I've translated are effective and even resonant, but cannot completely capture the awe evoked by nature. While fabricated worlds can trans-port us to fantastic, wild, and unusual destinations, no matter how good our simulations get, reality will always retain unique power.

Exponential technologies that propel change at an accelerated speed blur the lines between natural and facsimile. Just as your GPS has diminished the need for maps and the likelihood of getting lost, augmented realities provide encyclopedic amounts of information about everything around us. This can enhance our lives, help us make better decisions, and be far less likely to forget a person, place, or thing. Virtual and augmented realities help with medical issues from stress to surgery; they offer faster and more powerful personalized strategies to accelerate learning and train people for complex, expensive, or dangerous jobs, and yet...

Our connection to the natural world is fading.

You see, these same miraculous technologies, coupled with the science of addictive game play mechanics, can pull people into virtual experiences in ways that overtake and supplant important connections and

interconnections. Our understanding of reality is changing in ways that deeply impact how we think and feel about the environment, nature, and even politics. When forced to go offline, many of us are lost without our GPS and search engines, even in familiar places. When we do arrive, we race to take and post the best photos as proof of (and often instead of) presence, before racing to the next photo op, never really being where we are. Even when we *are* paying attention to nature, we augment perception with enhancements that fundamentally change our experience of reality.

It's becoming increasingly rare for people to slow down to take in the awe of the natural world. Where are those ants going? Where does this creek flow? What lies beneath that rock? Even strolling down a street, we seldom make eye contact, much less speak with the other actual humans we pass. We choose instead to stay transfixed by the simulacrum we clutch in our hands.

As we move inexorably toward living at least part time in virtual realities, as more of our experience is filtered through a virtual or augmented lens, important questions arise.

The answers are not simple.

Are you the mortal bag of flesh, bones, and blood reading these words? Is the real *you* your mind and the fragile container of your body less important? When your mind plugs in to become your avatar in a virtual world, puts on augmented reality glasses, or even remotely controls a robot or drone, where are you? What responsibilities does your avatar-self have for its actions in virtual worlds? What about its actions toward other avatars of real people?

Once we are fully immersed in the virtual world what will remain of the role of the natural world? Who will return to it? Who will protect and care for it? Will we still care about each other?

Who are you...really?

John Mack has asked these questions and more, spending years not only seeking answers but discovering ways to communicate them. As with all great art, you will find his photography and his poetry transcend

descriptions of nature and humanity as he holds up a mirror reflecting our modern selves. He compels us to consider where we are as individuals and a society as we evolve into our collective augmented future... and where we should be.

These are urgent reflections for us all. The future is no longer the moment following this one—it has arrived. See for yourself, in the pages beyond.

— **Richard Garriott de Cayeux**
Astronaut, explorer, author, and videogame creator.

"For this is what America is all about. It is the uncrossed desert and the unclimbed ridge. It is the star that is not reached and the harvest sleeping in the unplowed ground. Is our world gone? We say 'Farewell.' Is a new world coming? We welcome it—and we will bend it to the hopes of man."

— Lyndon B. Johnson

The Interstate

I've traveled most the interstates
Through many different land e-scapes,
But I've yet to see a trailer home
Hasting past me as I've gone.
I just assumed the driver thought
His home too heavy (decided not),
But now I realize my mistake:
The home no weight, but inner state.

Coloring Mount Oberlin: First Warning

What happens, you see, is that
our own adult minds reprint the coloring books —
the reproduced, black and white images
of our unsolved but case-closed mysteries —
for our open-minded children.

They color outside our lines because
all limits are relative; the adult's rule
for a child a mere suggestion.
And we must ask:
Does punishment follow? Look at us

now, punishing ourselves, machine-printing
lines we forgot how to color, much less
break. The crayons?
Desperate for yellow-sun
we've chosen gray-

boredom. What's left?
Unwilling to nurture the child,
we turn to our screens:
"Let's see what colors *they* pick for me!"
Confined in our rooms,

we *feel* free.

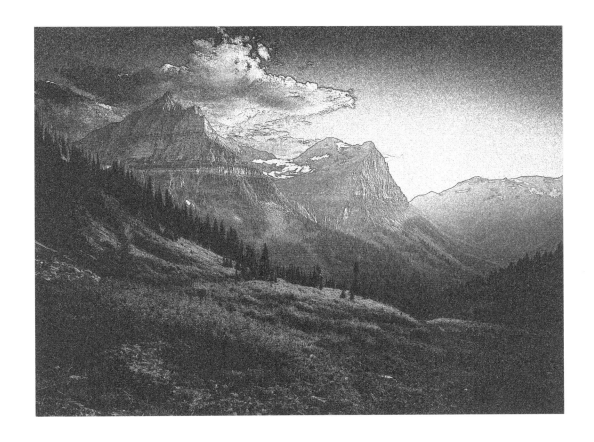

⊿ No Signal
<\PROGRAM>_ **Grief**

Glacier National Park
Mount Oberlin

Montana, USA
19 July 2018

The Dusk of Wabanahkik

Arcadia, perhaps, was
 the mainland of an Indian
 community made of individuals
 colored by harmony;
 the natives
 of nature
 with nature
 their nature.
This *was* nature's coast.

Acadia, it is known, is
 the Maine land of European
 individuals made of settlers
 paled by discord;
 the natives
 of nature
 displaced
 against nature.
This *is* America's coast.

Arcade, it seems, will
 mainline all Man,
 rendered soulless in a graphic
 massacre by design;
 the displaced
 against nature
 displaced further
 from nature.
Will *this* be the New World's coast?

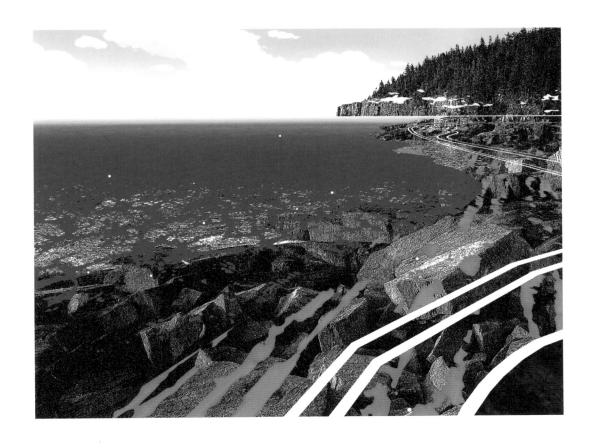

■₀₀₀ AT&T **Spotty Signal**
<\PROGRAM>_ **Displacement**

Acadia National Park
Monument Cove

Maine, USA
2 August 2017

Singing Psalms by a Campfire in Zion

There is a river, the streams whereof shall make glad
 The diaspora of Men.
Though the earth be removed, and though the mountains be disappeared,
 Here will be pitched the tent of the future camper,
A tabernacle of light construction in Zion
 National Park.
And the ransomed of the Designer shall arrive, and come to Zion
 With songs and everlasting joy inside their heads:
They shall obtain joy and gladness, and sorrow and sighing shall be distracted away.
 The Designer loveth the park gates of Zion
More than all the dwellings of nature itself.
 Come, behold the works of Man,
What desolations he hath made in the earth.

ıll AT&T **Full Signal** Zion National Park Utah. USA
<\PROGRAM>_ **Metaverse** Virgin River 18 January 2017

Rio Grande

Before we go to war
For the interests of someone
Other than our Selves,
Let's meet each other,
Amigo, you and me
From "south" and "north," and join hands
Here, in the landscape of our pain:
The common ground of all borders
Where separation was nothing
But a natural river misused for the artificial
Currents of programmable minds.

Let's meet each other here,
Amigo, you and me,
Never to backtrack toward the engineered
Constructs of one-dimensional walls
And virtual color
Labels, but remain steadfast,
Devoted to truth;
Lies dissolving
In a river so grand
As to give life to all who sip
Of the one ground below it.

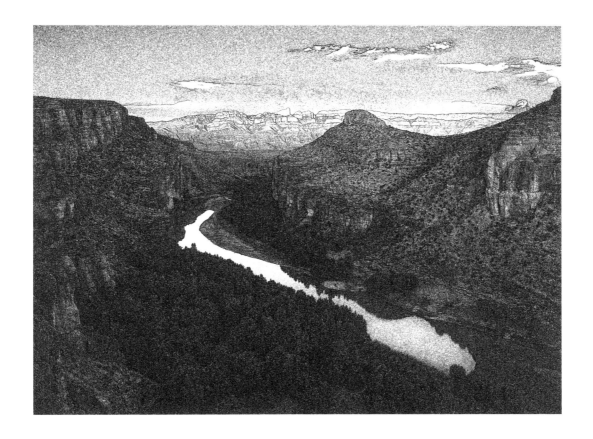

No Signal

`<\PROGRAM>`_ **Separation**

Big Bend National Park
Rio Grande

Texas, USA
21 March 2017

Wrangle: A Note to the Linear

Somewhere
along a horizontal path,
the right foot,
misplaced,
places itself perfectly
to guide you toward
the perfect place. Right where you are,
wrong is how you feel, empty
what you see. Fear

in the left foot, frozen
faithless, resists the right footing.

You've come a long way
to be
here, traveler, to wrangle
with this last step
between the death of your past
and the grieving of its future. Step

up.

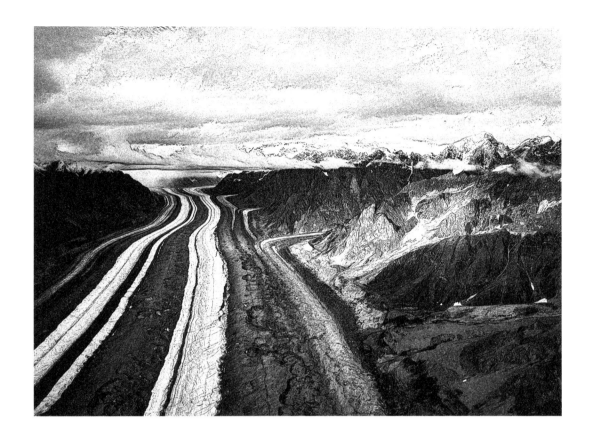

᠁ No Signal
<\PROGRAM>_ **Longing**

Wrangell – St. Elias National Park
Barnard Glacier

Alaska, USA
10 August 2018

Liberty Bell Mountain

If Washington were to pass here and overlook
the free country he helped found,
I wonder what he would say
of the black and white outline lived in
we, the people.
Yes, we can color it with any media:
CNN, Fox — the many acrylics of opinion.

My opinion?

The flag a billboard, the Presidency a brand;
"Yes We Can," "Make America Great Again,"
HARPO can, yay West?

The Liberty Bell is cracked,

let's face it; such are the fates of bells
and whistles when exposed to the vibration of Truth:
True freedom resonates too deep for the material.

"Take the road beyond the continental divide," he'd say,
"back to the purple mountain majesties,
to the dawn still breaking over the summit's peak.
Hear not a tinny 'chime,' but feel
the humming pulse bestowed upon us, sent
from the endless depths of the Universe
unknown, to which dance
the stars and stripes
of comets within us."

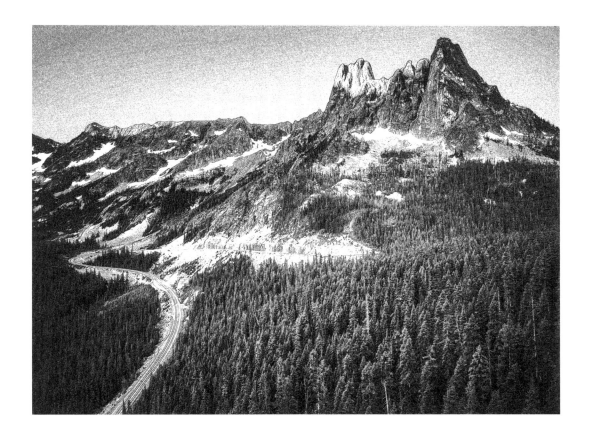

No Signal

<\PROGRAM>_ **Fear**

North Cascades National Park

Washington Pass Overlook

Washington, USA

15 July 2018

The Keyhole at Isle Royale

Sailors navigating their arrival
Toward that shore of Superior isle
Encounter short of northeast dock
Amygdaloid Island and its Channel:

This mundane formation of earthly rock
Obstructs one's passage — The Keyhole locked —
Yet this same complex has further might
And obstructs once more in limbic block:

For most us vessels at The Keyhole sight,
(Within our crew, poised with sleight),
Stands tall an image, great mutineer,
Who takes the helm in fight or flight:

And as either choice is steered in fear,
Then what route is there for "pioneer"?
Ah, the key rests in a Captain's spright
In trusting that the coast is clear.

Isle Royale National Park Michigan, USA
The Keyhole 18 May 2018

Rock Formation

Were you taught in your schooling
how to hold the landscape? I, myself,
studied rocks in geology: wind and water
(the catalysts of erosion), tectonic plates
(convergent, divergent, transform).
Environmental science taught me the telluric
currents: jet streams, weather patterns, and,
well, all the rest of it. But

what of It?

Did this education teach me of the wind
in the exhale, or of the precipitation
in the tear? Did it provoke the tectonic shifts
of evolution or expose the telluric currents of thought?

No.

What physical abuse is for the body
is what intellect has become for the mind: trauma.
To embrace a landscape is to let go of it.

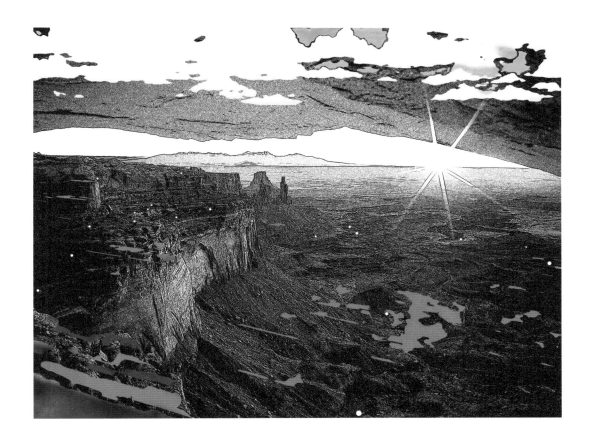

▬▮▯▯ AT&T **Spotty Signal** Canyonlands National Park Utah, USA
<\PROGRAM>_ **Anxiety** Mesa Arch 2 November 2018

Were You Alive, Not so Long Ago?

 — not so
Long ago — during the old days,
When apples grew on trees,
When El Capitan and Catalina were of national parks,
When a galaxy couldn't be owned, and
When Amazon and musk aroused images of earthly woods?

Were you alive —
Long ago — during the old days,
When fanaticism warned of "terrorism,"
When ethnic cleansing was deemed "genocide,"
When a species' extinction wasn't confused with "progress," and
When "genius," like Einstein, meant carrying the bouquet of humanity?

Were you alive — not so
 — during the old days,
When being old-fashioned didn't mean having a soul,
When parents weren't on the sidelines watching their children die,
When those aware who warned were shunned, and
When the last remaining hope didn't rest in a miracle?

Were you alive — not so
Long ago —

Were You Alive, Not so Long Ago?

— not so
Long ago — during the old days,
When apples grew on trees,
When El Capitan and Catalina were of national parks,
When a galaxy couldn't be owned, and
When Amazon and musk aroused images of earthly woods?

Were you alive —
Long ago — during the old days,
When fanaticism warned of "terrorism",
When ethnic cleansing was deemed "genocide",
When a species' extinction wasn't confused with "progress", and
When "genius", like Einstein, meant carrying the bouquet of humanity?

Were you alive — not so
— during the old days,
When being old-fashioned didn't mean having a soul,
When parents weren't on the sidelines watching their children die,
When those aware who warned were shunned, and
When the last remaining hope didn't rest in a miracle?

Were you alive — not so
Long ago —

Were you alive

not so

Long ago

when you could have made a difference?

A Subject's Objective: Climbing High Dune

Like most park visitors, you
begin your ascension to the High
Dune following the shoeprints
of those before you — Salomon, Merrell —
pilgrim that you are, devoted
to a branded path. To step

up feels a step down: From under you
the slide of sand, their sleight of hand
condemning your footing to the grain
of gravity in guilt. Belief,
the most wholly sacrifice of the masses,
lets you down

to finally doubt. Now, each step higher
an increasing wind
born of your own vertical persistence
comes to fill full the depressions
of all tracks, past and future, transposing
the dune. It leaves nothing

but ripples— a delicate surface, shifting
impermanence all around you. Gone
the path to guide you forward, gone
your traces to guide you back, a history
of scripture erased by a
blown truth.

And now? Stranded and alone
atop a desert slope,
a subject desperate for an object
for faith, for hope, for love
you tremble
before the valley's depths:

Could you be It?

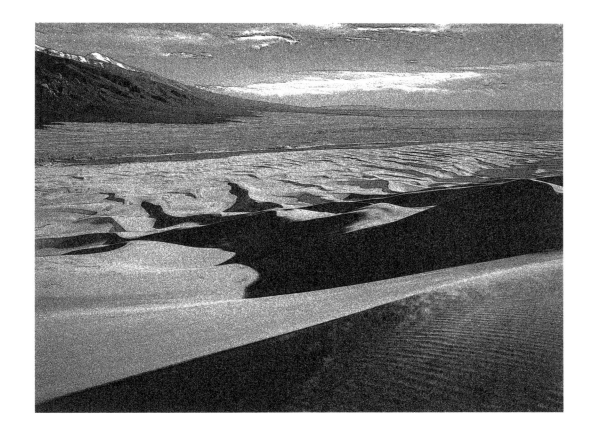

No Signal

<\PROGRAM>_ **Doubtfulness**

Great Sand Dunes National Park

High Dune

Colorado, USA

16 May 2017

Grand Canyon

Under these lies awaits the Grand Canyon

 that you avoid looking into,
 for the shedding of a grieving tear
 risks to carve it deeper. Damn you
 upstream with the rest of your anguish, blocked
 in the memory reservoir where suffering's
 gravity generates power for the established grid.
 "Objectify her," you say, "and color me from myself."
 You, man, exploiter of the nurture in her

 Nature. River of her pain, you turn away
 at the site. Her flow would spark your own
 but she's been passive until now: Time to own up
 stream! Open yourself with the flood
 Gates to the Kingdom,
 Release yourself down to the final, carving gush:
 Bottomless apology; bottomless gratitude.
 Communion. Humble the tender waterfalls

to eternity.

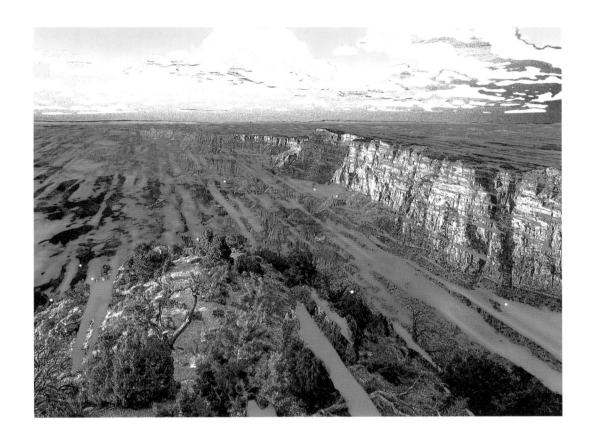

▮▯▯▯ T-Mobile **Spotty Signal** Grand Canyon National Park Arizona, USA
<\PROGRAM>_ **Suffering** Desert View 25 September 2017

Kearsarge Pass

This is why we amateurs reach
for our cameras. Go ahead,
put the phone between
yourself and Kings Canyon. Shoot it
all you want, but it won't change
anything; it being no different
than the disconnect which prompts you
to reach for it in the first place: The incomplete

experience pocketed
for completion at a more convenient time. But when?
At home on a computer screen?
With likes on social media?
What is there

to share, really?
Half?
A portion?
A potential
of what could have been? Is this what our nature is
worth? A pass?

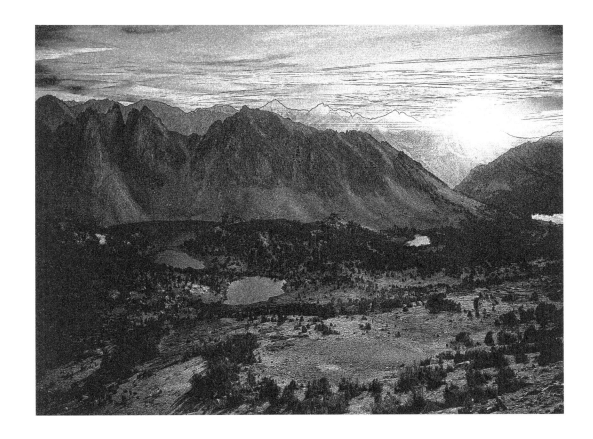

No Signal
<\PROGRAM>_ **Incompleteness**

Kings Canyon National Park
Kearsarge Pass

California, USA
28 October 2018

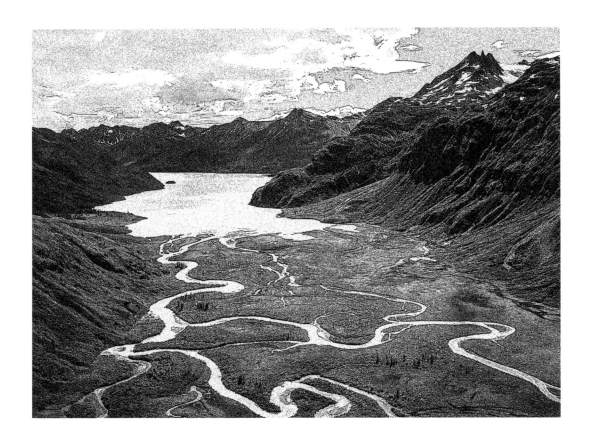

No Signal
<\PROGRAM>_ **Nullity**

Lake Clark National Park
Crescent Lake

Alaska, USA
7 August 2018

Crescent Lake

reserved on a plane
(usually a float)
located in the higher heart
of the Chigmit Mountains
regarding a glow,
the turquoise of thymus, colored
by way of a crescent body
of water,

Crescent Lake

reserved on a plane
(usually a float)
located in the higher heart
of the Chigmit Mountains
regarding a glow,
the turquoise of thymus, colored
by way of a crescent body
of water.

There is a seat…

…with your name on it.

Crater Lake

Its purity, crystal clear, is
 a matter of Source:
 precipitation, coalescing, feeds to it
 the skies—
 a circle completely
uncontaminated by the networks
of tributaries formed outside itself.

Its volume, balanced, is
 a matter of Gratitude:
 the offering up, evaporation,
 reciprocating what it can—
 a vertical relationship
unlike the broad, casted channels
that lie in horizontal communication to dual seas.

Its contribution, effortless, is
 a matter of Duty:
 seepage of source from within,
 outward—
 percolating presence
into meandering streams
of earthly consciousness.

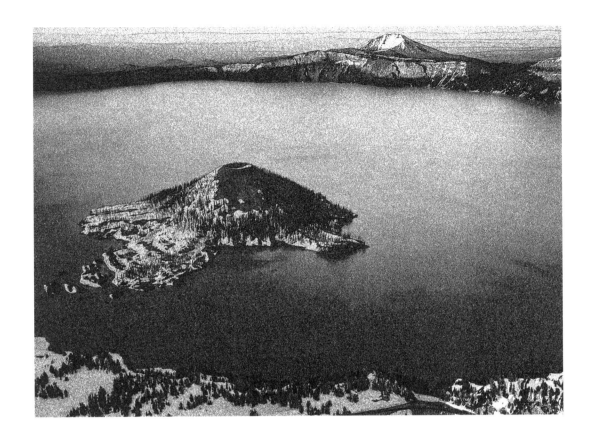

No Signal

<\PROGRAM>_ **Separation**

Crater Lake National Park
Wizard Island

Oregon, USA
14 June 2017

Waxing Reminder

I won't lie to you
Like we do to ourselves:
There is fear
At the site of the Empty.
Sometimes it comes
In the company of loneliness,
Sometimes having achieved failure.
But, regardless, it is
Loss of a color assumed
As "me."

When the home is emptied,
What remains?
We still breathe,
Do we not?
Pure aliveness lurks in that pain.
Will you find your colors
Before others color you?

"Steadfast to your fullness,"
Hints the waxing moon,
"There is light in the darkness."

From Tipsoo Lake to Paradise

This view lies literally just outside of Paradise
(thirty-five miles, to be exact— one hour by car),
and those who have experienced the spring know
the winter traveler will be deceived by distance
with their seasonal closure of Stevens Canyon Road.

From Tipsoo, spring's access begins on the paved hill
where most have parked their vehicles in Comfort
Station. Then, if one endures the immediate need to switchback
— left then back then right then back then left then back —
it is left up to the driver to spot the right

turn, toward Grove of the Patriarchs Trail
(a tree esteemed by many not only for his firm height,
but for his curved, mystical shape, as if sculpted in light
of the moon's glow, spun to the rhythm of her orbit). Yet
even then, it is not until the memorable Picture Frame Falls

that one truly begins to realize where the canyon road is
leading them: to the sight of Self, not in an image
framed but in the crystalline waters of Reflection Lake
(a mere ten miles further), where begins Wonderland
Trail. At that location, well, one is pretty much home

free. Paradise Inn will be just up the road
offering lodging, a general store, and a gift shop. And,
as if those amenities weren't enough,
I recommend the Caramel Banana Waffle for $14.25
since, no matter the time you arrive,

it will probably feel like morning.

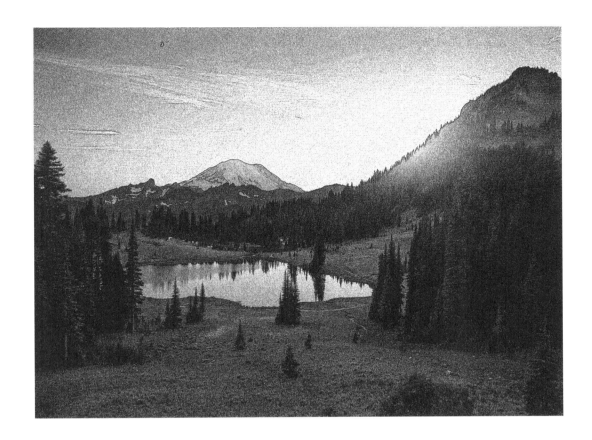

No Signal

<\PROGRAM>_ **Distance**

Mount Rainier National Park
Tipsoo Lake

Washington, USA
16 July 2018

Point of Inspiration

I've come this far
to arrive
for sunset, though the
forecast broadcast
before me is
"overcast."

 I cast a prayer —
 beg! — that it change
 the channel.
 My condition
 in such conditions
 cannot channel.

 I stand my stubborn tripod here
 and wait...
 wait, perhaps there?
 Tripod here?
 There we go— right here;
 my position the only condition.

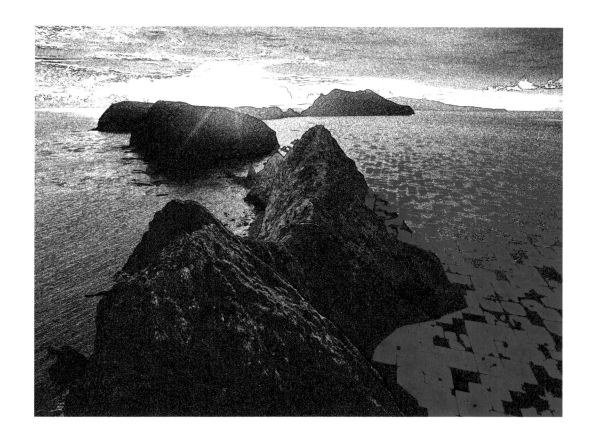

▁▂▃▅ AT&T **Spotty Signal**　　　　　Channel Islands National Park　　　California, USA
<\PROGRAM>_ **Preoccupation**　　　　Inspiration Point　　　　　　　　3 November 2017

The Good and the Badlands

I came down from above,
no, no stork.
Duh!
(Delta.)
Touched down

in Rapid City Regional,
where the innocent school drive begins—
right to Jolly Lane, left to Jubilee.
Then joyride swerves in the rental:
the psychological Hertz.

I'm told home is south of North
Dakota which is north of South
Dakota, and that a good boy
steers West of the Badlands.
I part ways at Sixteen, an enticing bypass

toward the highway East
bound.
(Hey, they were warned about adolescence!)
Yup… I took 'em for a spin
alright, my Self included. Later,

it wasn't the sun but my shadow
that revealed the lay of the land,
in the fall of light, as
a sunset reveals the day.
It dawns on me at dusk:

The gas spent on experience,
the wheeling, tiring revolutions,
only to return back
to my arrival — to that place
I already knew

now new —
where Good knew no good, nor bad
knew no Good, and where Rapid City,
slow as it is still,
was never regional.

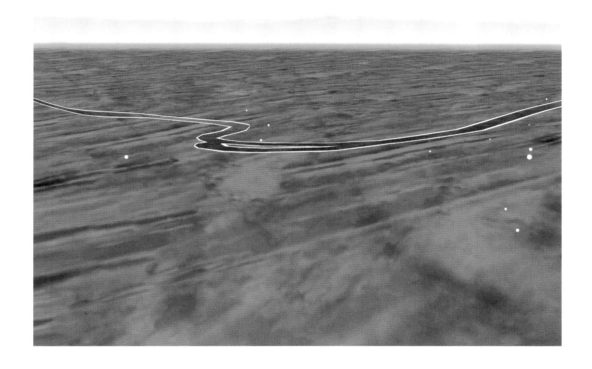

॥। AT&T **Full Signal** Badlands National Park South Dakota, USA
<\PROGRAM>_ **"Arrival"** Conata Basin Overlook 14 May 2018

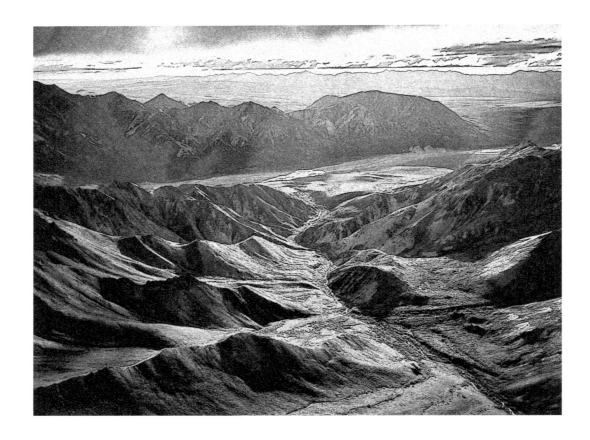

No Signal

<\PROGRAM>_ **Longing**

Denali National Park
Toklat River

Alaska, USA
15 August 2018

From "Chris" to Alex to Chris: Into the Wilderness of Denali

Two years he walks the Earth,
 a shout of resentment answered by the call of the wild:
No phone, no pool, no pets, no cigarettes
 (pockets emptied) but
Ultimate freedom
 Still tied up with the mind's contents.
An extremist
 on the outside, an average man within —
An aesthetic voyager whose home is the road,
 predictably paved within the margin of reaction:
Escaped from Atlanta
 because of what "they" said, and
Thou shalt not return, 'cause "the West is the best"
 is what "another" said.
And now after two rambling years comes the final and greatest adventure:
 To unplug the program that was never him;
The climactic battle to kill the false being within and victoriously conclude the spiritual pilgrimage:
 Memory emptied at the Last Frontier.
Ten days and nights of freight trains and hitchhiking bring him to the great white north
 where a blank canvas awaits the colors of his nature,
No longer to be poisoned by civilization he flees, and walks alone upon the land to become lost in the wild
 for the sake, it will turn out, of sharing his happiness with us.

— Alexander Supertramp — John Mack

We, the Caribou of Kobuk

Some say it is the wind —
its message of changing seasons, its gusts
repelling the million mosquitoes —
that guides us
through the longest of all terrestrial migrations.
It is a journey of life through three landscapes

beginning as high as Lookout Ridge,
 the spring
calving grounds, north of Western Alaska's Brooks Range,
where pregnant cows have
instinctively returned for the new life. Our path

south, a descension into the Migratory Area,
 commenced with the fall,
down into these Kobuk latitudes where the herd is most
prone to predators, including wolves
and hunters who count on our continued migration

into the lowest realm, the realm of human harvesting,
 during the herd's time in the Winter
Range. This third landscape is one of strategy
between nature and man, where manmade "drive lines"
ensure that those caught will never return to spring. But, then

again, it is the wind that may largely decide our fate,
for, though it may seem rare, its call,
like an act of grace,
may alter the seasonal pattern of such low descent,
ultimately steering the herd above man's low-level devices.
That said, today's hunters have brave, new ideas for their game.

Have you sensed the meddling in the wind?

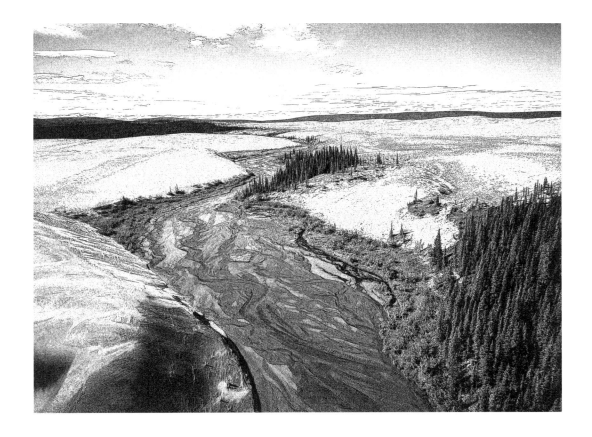

No Signal

<\PROGRAM>_ **The Fall**

Kobuk Valley National Park
Great Kobuk Sand Dunes

Alaska, USA
13 August 2018

~~Madame~~ Pele's Tears

No movement, no flow.
The inactive runs
contrary to Spirit.
Viscous sensuality, blood
life of the chasm, crusted
stiff by Mister Seismologist:

"Tectonic plate isostacy
over the visco-elastic makeup
of the asthenosphere permits
shifts, or 'drift,' as proven in
the relocation of mafic
eruptions over time."

Sounds reasonable enough,
and for good reason:
The tremor of fear— a "volcanic
complex" intent on understanding
source. She's "relocated," not dead.
(Yet)

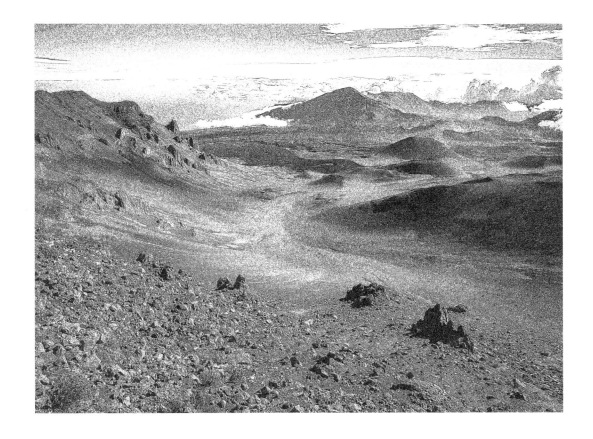

No Signal

<\PROGRAM>_ **Sorrow**

Haleakala National Park
Haleakala Visitors Center

Hawaii, USA
24 January 2018

Virgin Islands

Behold! — the look of virgin land
for tomorrow's generation of natives
who will never know the natural
park. Here lies the primordial island
paradise of the new world,
unscathed by the contamination of human
clay that once polluted
earthen shores with latent sapience;

Behold! — these virgin islands, cradle of the coming
indigenous cultures; avatars
destined to design the legends and render the myths
as to rig the way home for those anomalies
who arrive in reconquest. Look out, foreigner,
upon the cliffs at Omega Point, their sacrificial altar,
where the tide of hope recedes
over an alternate horizon.

Version 1.21.0

Is this the current version
of Paradise? Remember the one
with the turquoise water
and the palm trees? Was it
deserted island or desert oasis?
The ideal dream

now pixeled
in the monitor; fragmented light
spoofing single source.
Unplug it!
Paradise is what happens
when its image goes to Hell.

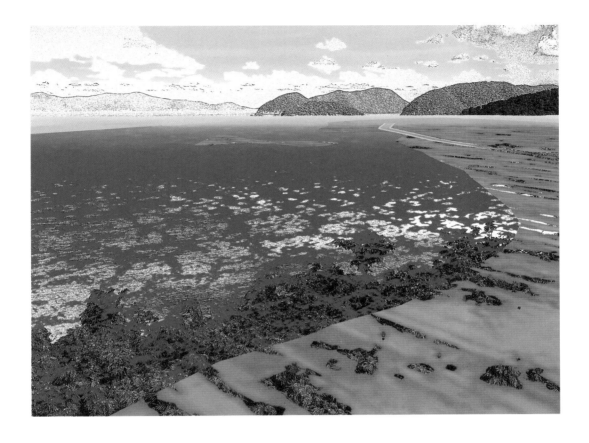

▂▁▁▁ AT&T **Spotty Signal**
<\PROGRAM>_ **Memory**

Virgin Islands National Park
Trunk Bay

St. John, US Virgin Islands
1 January 2017

"Salutations" from the American Novelty of Silicon Valley

The captivation works no differently:
A spider spins the mesmerizing
Trap — the mandala's depth in flatness;
A smart device of nature.
Its goal is the same: to suck the lifeblood from the winged.
Still, screens are drawn to shut you out,
But these days the designer is a "he,"
Charlotte; the child's joy of your thread
Outspun into the world
Wide web of a new weave.

In Significance

Insignificant my big thoughts
Render me in the valley;
I'm inversed
Under the mountains as is
This roadrunner below sea level.
With the parched salt grain we inhabit
The Badwater basin; shimmers of penance
Under a winter's desert sun.

Significance itself my emptiness
Renders me atop the mountain;
I'm inversed
Above the valley as are
These stones having taken flight.
With the dust we inhabit
Aguereberry Point; drenched
In the fertile desert of death.

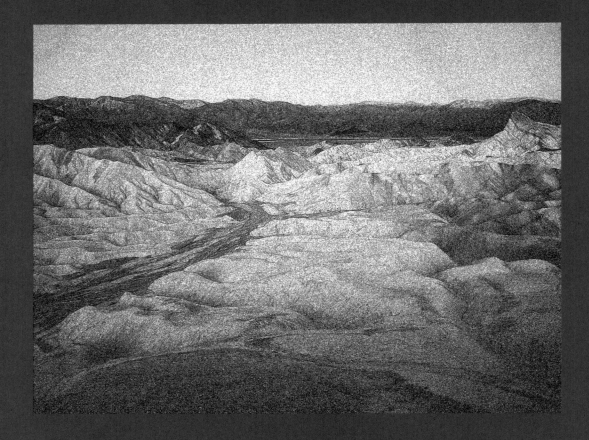

No Signal

<\PROGRAM>_ **Despair**

Death Valley National Park
Zabriskie Point

California, USA
29 September 2017

Death Valley

A harsh environment conditions
The site barren, blinded
Below see level. A ground underground:
Sweltered, smoldered, scolded
"No!" at any possibility of new
Life. Yet out of Death

Valley, it is said — shh —,
Under "perfect conditions,"
Awaits gold
Desert wildflowers of the rare
"Superbloom," a glimpse, ephemeral,
At the one true
Gift for the human condition:

The perennial.

Beached

The blind ocean longs
to see herself in your eyes.

She waves.

If only she could see you
now, blind on her shores,

texting.

Driftwood on Rialto Beach

I agree. These driftwoods are but relics of a dream.
But so are the abandoned children of our youth;
Twisted manipulations of nature's poetry.

Forgive me for having twisted this poetry.
I mean, "How could I?"
Well,

How could we?

They have been uprooted from a weak foundation,
Have they not? Been torn, windblown, battered
By the currents and upheavals
Of storms that were never their own to begin with?
Victims?

Without question.

Scorched colorless by the low tide scolding,
Contortedly gestured by the high tide agenda.
There's an entire line of lush ones ready to follow suit.
And you?

Do you remember yourself in the greenery?

"But they've lived a full life," you say. "They've grown
tall, old, withered, and are merely following
the cyclical pattern that is life."

You want your driftwood back,
but I'm speaking of the child in *you*.

You can have eternity's artistry —
The gravestones of time,
The resurrection of the timeless. You can have It
For what It is. But one must first fall
The "cyclical pattern that is life."

You can have your poetry,
But first your nature.

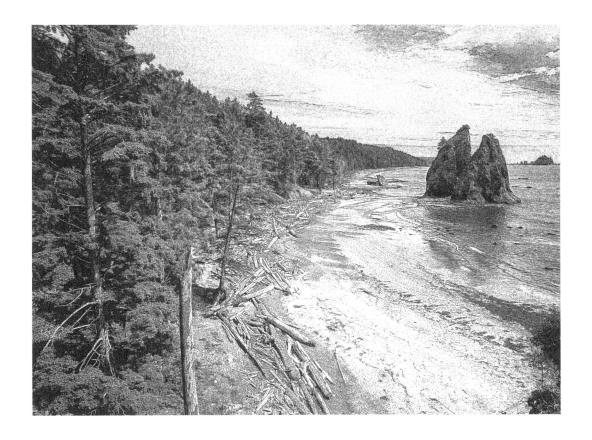

⣿⣿. No Signal

<\PROGRAM>_ **Abandonment**

Olympic National Park
Rialto Beach

Washington, USA
8 July 2018

Gates of the Arctic

The gates of the arctic
halo, circle of latitude,
towering tall above the lower
forty-eight that attempt
with religious code,
login password,
new age key,
spiritual knock
off, respond only
to the vibration
of the buzzer's
ring: "Pass-not."

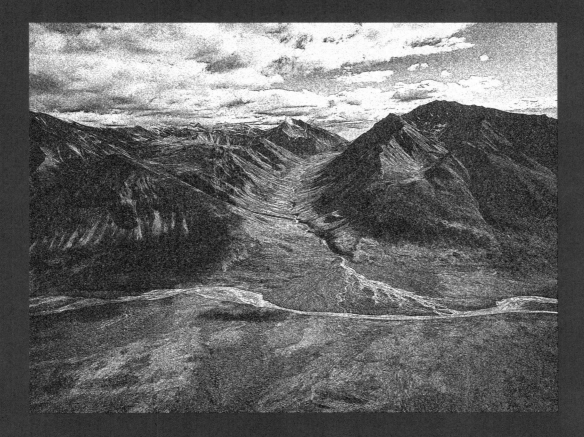

No Signal

<\PROGRAM>_ **Doubtfulness**

Gates of the Arctic National Park
Tupik Creek

Alaska, USA
13 August 2018

The Pandemic Slipping Through Our Politicians' Fingers

I awake, wide-eyed, from the nightmare
of a virus breaking into our home
through the open door policy
in our pockets: Devices,
lawless and backward. It was I who was the one on trial,
quarantined in the isolation that most exposes
her: online schooling, online birthdays, online play;
life on the line.
Exhausted, I was doctor, lab researcher, detective, law enforcer—
all that a parent must be
during such times of contagion.
An Apple a day?

As if still in the dream,
 I switch on my bedside lamp
 and venture out to check on reality:
 Tiptoeing under the sound
 of a faint inhale that leads me
 into the balmy room of her own heat,
 sheets pushed aside
 down to the toes, her innocence
 vulnerable in complete abandon
 under the protection
 of the green dinosaur and ragged bunny,
 wide-eyed in the night
 who reassure her,
I sigh in relief:

She is still human.

Unconscious Artistry

Your eyes trace as upon tracing paper
And, with mind's swift artistry,
Accomplish to camouflage its lucidity
Before realizing it.

A surface brought to life,
Nothing more;
The essence, blocked by your image,
Behind it.

Process spans the distance of the separation;
Effort comes naturally to you;
You trace a river's bending
By the work of time's doing, unaware

Process spans the distance of the separation;
Effort comes naturally to you;
You trace a river's bending
By the work of time's doing, unaware

That effect is its cause,
On the other side, where sanity observes
You miming a wall: non-existent
Surfaces are impenetrable.

That effect is its cause,
On the other side, where sanity observes
You miming a wall: non-existent
Surfaces are impenetrable.

God made you
In God's image, and
You process God in yours:

God made you
In God's image, and
You process God in yours:

Flat.

Flat.

ıl AT&T **Full Signal** Theodore Roosevelt National Park North Dakota, USA
<\PROGRAM>_ **"Depth"** Wind Canyon Overlook 13 May 2018

Dear Ansel,

I'm standing here where you once stood.
I'm shooting here where you once shot.
But what of the different landscapes caught?
 The camera's fault?
 We know it's not.

Let's talk about the focus plane:
The depth of field from where we frame.
Your eye was on the land, you'll claim.
 And mine?
 My I cast on the same.

And what about the shutter speed?
(For perhaps it is a cause of time.)
Your patience for the deep sublime?
 I've swiped it right
 To their design.

But all in all comes down to light,
To the aperture where One's exposed.
Open you were, nature composed.
 And mine?
 Virtually closed.

I'm standing here where you once stood.
I'm shooting here where you once shot.
But what of the different landscapes caught?
 Your inner pure,
 This one besot.

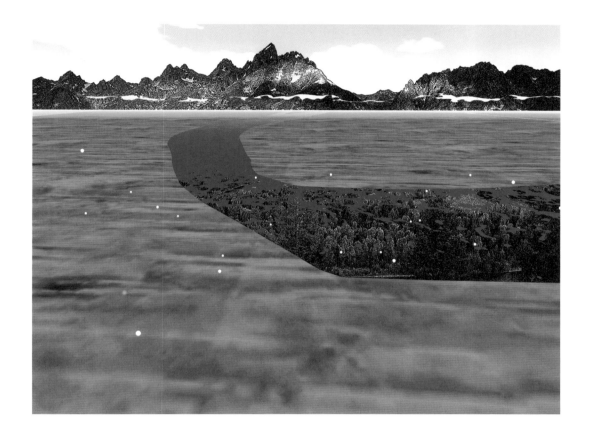

▎▫▫ AT&T **Spotty Signal** Grand Teton National Park Wyoming, USA
<\PROGRAM>_ **Restlessness** Snake River Overlook 30 August 2017

Battle Lake

There are lakes deep within
our region's interior
polluted by our science
of the shallow claim; oligotrophic
blues contaminated by
the mind's nutrients: evidence.

Of drowning the color
limnologists beware:
Clarity of reason
obscures like algae.

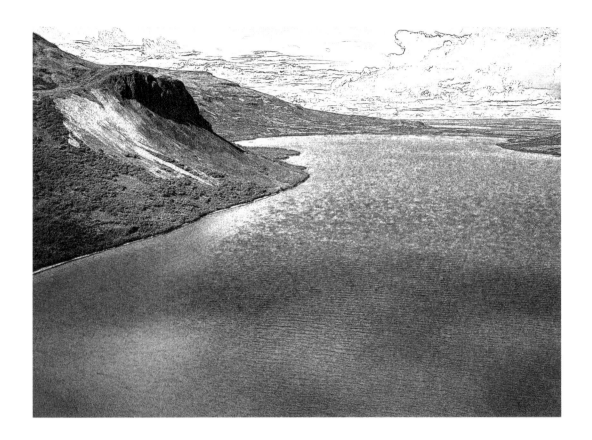

No Signal

<\PROGRAM>_ **Meaninglessness**

Katmai National Park
Battle Lake

Alaska, USA
7 August 2018

Wind Canyon Overlooked

Photographers claim, "It's when the magic happens,"
and they either rise before dawn or wait until dusk
to capture it.
But even then
the only captured magic is in the appearance
of an image on the once-ordinary,
plain, washed out Ilford;
Poof!
 the original escapes its version.

And what of the time between,
when, we must assume, the magic doesn't happen—
the time spent looking anywhere other than at the ordinary
plain, washed out
under the high-noon sun?
Should we give it magic?
The blind magician waves an iWand;

Wind Canyon Overlooked

Photographers claim, "It's when the magic happens,"
and they either rise before dawn or wait until dusk
to capture it.
But even then
the only captured magic is in the appearance
of an image on the once-ordinary,
plain, washed out Ilford;
Poof!
the original escapes its version.

And what of the time between,
when, we must assume, the magic doesn't happen—
the time spent looking anywhere other than at the ordinary
plain, washed out
under the high-noon sun?
Should we give it magic?
The blind magician waves an iWand;

Poof!

it disappears.

Shooting Northern Texas, 3 August 2019

On the day of this shot
A less than human image
That merits no place in
Nature's truth, leaving
Evidence of the Great Replacement
As a point of departure
Ignorant to the fact
That such visions
In themselves
Merely confirm one's own
Replacement from human
Being to hardwired
Automaton.

📶 AT&T **Full Signal** Guadalupe Mountains National Park Texas, USA
<\PROGRAM>_ **"Nature"** El Capitan 3 August 2019

No Signal

<\PROGRAM>_ **Yearning**

Lassen Volcanic National Park
Painted Dunes

California, USA
27 October 2018

Lassen Unstruck

History has it that
a fabled "Gold Lake" is hidden in this ashen.
 "No effort in digging,"
 "Nuggets free for the picking,"
in came Peter Lassen.

History has it that
others followed in stride of Lassen's upsetting.
 Nor gold for William Noble
 But, later, Native-land paved mobile
(now Susanville to Redding).

History has it that
the closest Lassen ever came was to honey—
 same color in appearance,
 and, funny, the coherence,
both confusing, like gold for money.

Today has it that
we are no different in search nor yearn:
 toward golden ideal
 we conceal the real.
When will we the lake discern?

Letter to the U.S. Geological Survey — Kenai Fjords, 9 August 2018

A question to whom it may concern,

Regarding the infamous Mobil botch —
the Exxon Valdez that veered off-course —
if it was the captain's vodka (or scotch?),
then why lift the glacial "hazard watch"?

You see, climate change has gone unchanged,
the Columbia Glacier ever more at risk,
as in modern negligence we now see range
from mobile spill to nature exchanged.

Funny that word, "exchanged," just dropped,
for regulatory oversight is just as crude,
since, from what I see, that watch was stopped
because you, dear Sirs, have hazards swapped.

Don't take this wrong, my words goodwill,
But the Federal, too, must fill the bill;
Nature? A hazard? Who's against what's will?
This keen eye view we must distill.

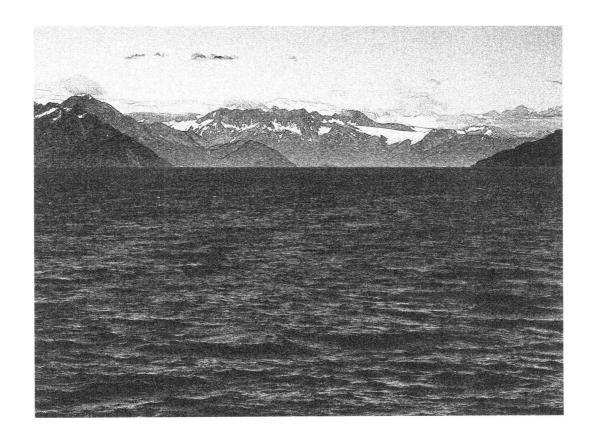

No Signal
<\PROGRAM>_ **Disconnection**

Kenai Fjords National Park
Aialik Bay

Alaska, USA
9 August 2018

Workshop Rules

Before we apply these tools
to this wood,
children, take note:

1. Measure twice, cut once.

2. If you take it, put it back.

3. Don't use it if you don't know how.

"Oops!"

at Dream Lake

Before we apply our thoughts
to our nature,
adults, take note:

1. Observe before you act.

2. What you've altered, you must restore.

3. Belief is forbidden.

"Good Lord!"

at Dream Lake

Before we apply our thoughts
to our nature,
adults, take note:

1. Observe before you act.

2. What you've altered, you must restore.

3. Belief is forbidden.

"Good Lord!"

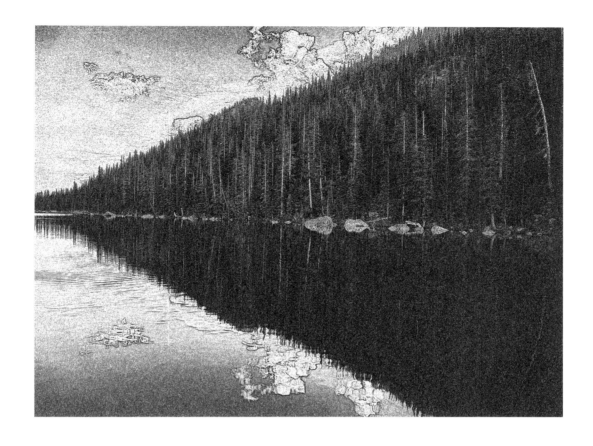

No Signal

`<\PROGRAM>`_ **Senselessness**

Rocky Mountain National Park

Dream Lake

Colorado, USA

6 August 2019

Return to Monument Valley

I suppose I left the valley by choice,
although I don't remember stating that
it was time to go. With my family in the car
I drove back
to face the life of things pending,
or better,
it was the life of things pending
that drove me back.
Did I have a choice?

Right before my eyes,
that which I had thought to be my final destination
slowly faded in front of me,
absorbed by the same mirage
from which it had appeared.
Ahead of me,
the heat of asphalt sizzled up the intersection —
Highway 160,
direction Phoenix.

My chimera, faded beyond a mind's horizon,
is but a glimmering memory.
How could something so monumental have been so still?
The sight of the butte trinity —
sands of past, present, and future —
solidified and contained within three-dimensional space —
has now eroded.
Upon what plateau had I stood
as to distinguish that which had governed my life?

A year has now extended
out of what I thought would be timeless;
the memory of the eternal valley now
my external trap, I vow to return the site to me
and, assuming it is within my power,
use my brain to trip itself—
attempting to carve canyons out of the deciduous
environment that often surrounds me.
Oh, the effort in trying to change how it looks!

Futile attempts
lead me to retrace my steps.
How had I arrived to see it in the first place?
No doubt it had always been there,
waiting for me— without waiting.
I recollect a shift in my positioning:
With each advance toward it,
an advance toward me—
a fact that frees me from the illusory trap.

I warm up
to the reminder that it was not a destination reached
but rather a deep valley sunk into,
so close in proximity that any effort
to return there would be to pass it by.
I step out of the air-conditioned gas station —
the Arizona-Utah border closer yet —
and let the hot, dry wind carve around
the pliant sandstone of my heart.

Saguaro Selfie

Click. Share
with the world your selfie
captured —
ribs,
spine,
arms
of a keystone species —
tell us
of the light, giant candle,
cereus gigantea…

Is it blossoming?

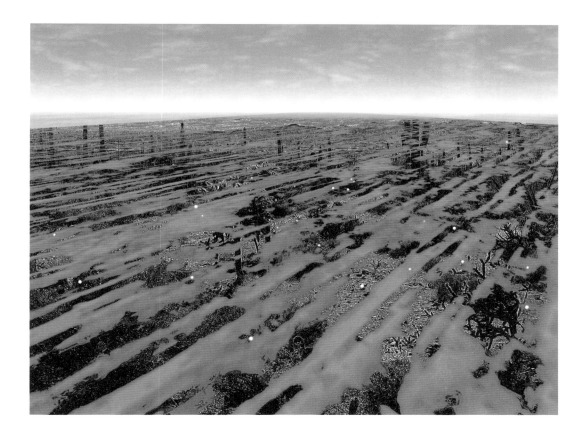

.ₐll AT&T **Spotty Signal** Saguaro National Park Arizona, USA
<\PROGRAM>_ **Doubtfulness** Kinney Road 7 November 2018

Glacial Retreat: Five Fun Facts!

* Botanist W. S. Cooper's 1916 cheering
 this the world's best spot for observing *plant succession*,
 in 1921 led a lobby campaign for steering
 Calvin Coolidge's decision in Glacier Bay's protection.

* *Plant succession* is the process of a given species' change,
 observed by scientists in a three-phase distinction
 that alters the structure of a community and will range
 from colonization to establishment and, ultimately, to extinction.

* What makes this bay exemplary is the result of *glacial retreat*,
 where melting, or *ablation*, exceeding snow accumulation,
 bares for colonization upon an empty land, replete
 with opportunities for a species' augmentation.

* Though some will claim it natural, there's speculation that
 a "manmade" climate change has now unnaturally evolved,
 altering species' compositions and, further, loss of habitat—
 meaning, according to their evidence, we humans are involved.

* For visitors in search of such connection and impression,
 a glacial retreat is possible on many a chartered cruise
 offering modern day amenities, such as mobile data reception,
 and a variety of other experiences up for all to choose.

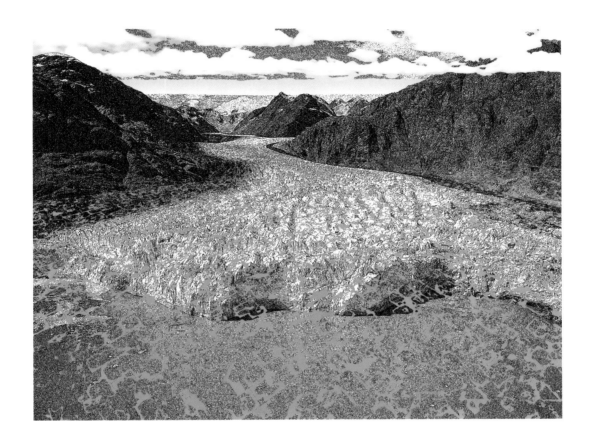

▂▃▄ cellular at SEA **Spotty Signal**
<\PROGRAM>_ **Concern**

Glacier Bay National Park
Margerie Glacier

Alaska, USA
5 August 2018

Halemaʻumaʻu?

This land is cause of the new hotspot,
the Hawaiian-Emperor overthrown
by data's eruption. People
flock to the signal; there is awe
where novel land flows: Millennia's
work smothered in an instant.
Millennials.
A pixelated soil fills the fissure
in the heart: illusory seeds;
endemic flora of mind.

Poke at Man GOING

Remember, as a child,
The disappointment of a rainy day?
The Joy of the sunlit?
To be outside was sure play;
Nature and the imagination,
It is our nature.

With what have we replaced the sunlit?
With what do we fill the darkness?
What, of our own devices, plays us?

Those who remember know
Today is a rainy day:
The joys of the screenlit.
Nature grieves, I imagine,
Its death in us.

Child of the future, what are you?

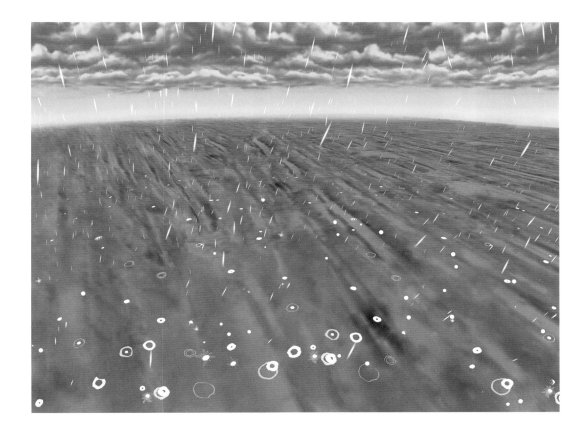

For the Everglades, We Pray

Regarding the mind-made
Everglades,
a soon to be made downgrade
arcade charade
ready-made,
displayed to betray,
to persuade to overplay,
overpay,
to overstay a grade mis-weighed,
not dismayed but okayed
(obeyed!)
by whoever severs
the eternal-laid
and plays wherever
whenever staid,
preyed, played
in every way,

we'd better pray:

To whomever strayed,
swayed to that manmade
clever endeavor
of the forever-grave,
upgrade, unafraid,
to the better than ever
then ever better
nature-made foreverglades.

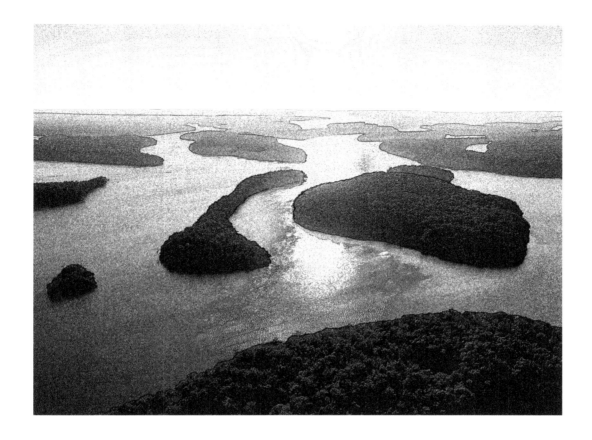

No Signal

<\PROGRAM>_ **Boredom**

Everglades National Park
Whitewater Bay

Florida, USA
19 March 2017

Winter Advisory from the National Park Service

Our national parks are endangered
lands. To even border them as "parks"
admits their bordering
on extinction.
Have you seen the bored poachers developing?
They are the now-contaminated. Wild
life they once were, roaming the natural habitat pure,
generations ago,
eons ago,
so far
ago that any
remaining remains remain
unexcavated below the crust of their
unconscious. And you,

who are you?

Have you excavated your child?
Have you uncovered the pieces?
Are you now-conscious
of the endangered species?
Are you aware
of what's at stake?

At this rate, those
who survive will be a mere attraction—
like the polar bear at the zoo,
like the native before the tourist;
nature an anomaly.
Is this how they'll look at us?
Sympathy at the sight of "innocence"?
Alas, the hallmark of a living machine!
Clearly, this has little to do with the future.

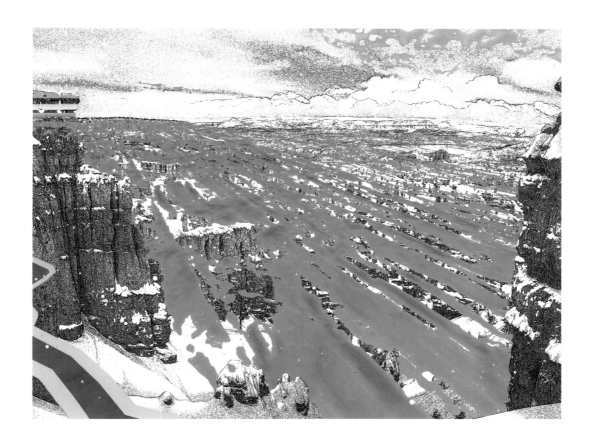

▫▫▫ AT&T **Spotty Signal** Bryce Canyon National Park Utah, USA
<\PROGRAM>_ **Angst** Navajo Loop Trail 8 December 2019

Tunnel View

Though they speak of a light
at the end of a tunnel,
they are not dead yet—
proof being that they live
to tell a story of distance.

As you are
not dead yet —
proof being that you are reading this —
then, if I may ask,
where is this tunnel?

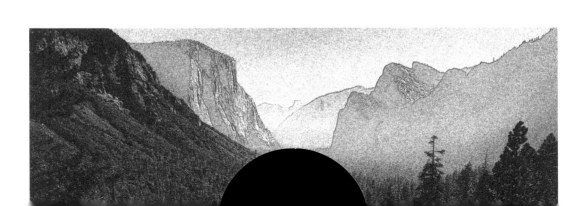

 No Signal

<\PROGRAM>_ **Darkness**

No Signal
/PROGRAM>_Darkness

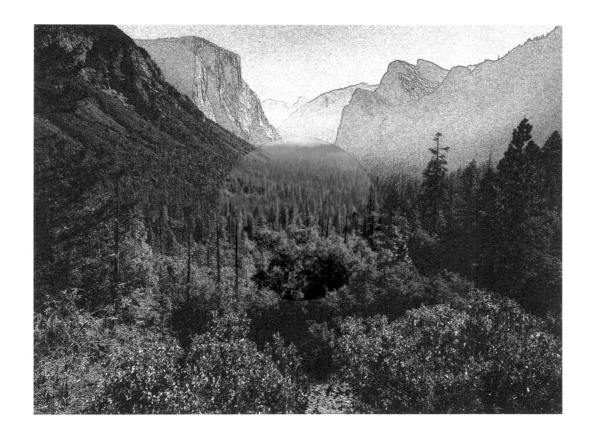

Yosemite National Park California, USA
Tunnel View 2 October 2017

Hall of Horrors

Powerless and empty, having
forgotten from where you came,
the night-watch of
loss stops you
in your tracks. You've fallen
into this inner desert
alone, ranger,
guided by the inevitable
emptiness that rose
out of the dusk
of setting content. Discontent? Nay,
despair— your only
truth, hidden
since the morning's easterly dawn of
color, having risen over
the Verizon line where land and sky met
entertainment, purpose,

meaning. Now you must find within
the darkness that there is
none. The land howls hollow,
summoning you to drop that weapon,
hand held,
and to turn yourself in
before the morn's release
of yet another
day's escape route.

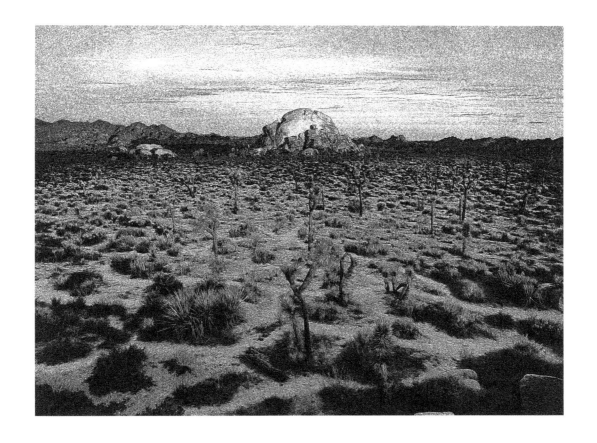

No Signal

<\PROGRAM>_ **Desparation**

Joshua Tree National Park

Hall of Horrors

California, USA

25 September 2017

Window Shopping in the US of A

I'm headed north toward Park Avenue.
I pass the courthouse, the bell,
The cathedral. Adjacent to the Capitol
I contemplate a coffee pot.

I turn left at the flagstaff,
Push my way through a crowd peering
Through an angel's window
At a horseshoe on sale.

Onward through the narrows
I pass the Court of the Patriarchs,
Then head to the subway entrance
Before pondering again over a checkerboard.

I pick up the pace, bypassing Wall Street
For a pair of mittens in the north window,
Followed by a wondrous site which too soon
Became a Mexican hat in the costume store.

Finally, I reach Park Avenue's structures:
The Courthouse towers, Babel,
A phallus in the window's section.
(Every city has its erotic shop.)

How far must one go
To erode the mind?
I decide on the less journeyed backlands
Of a national park. My guide

Warns me of the unpaved bentonite
As we drive out and beyond.
"Beautiful!" I exclaim.
"That's 'Factory Butte,'" he points out,

Clearly mistaking my want for sight
For sightseeing.
I hop out of the car and find a spot
To stand alone.

"Cut the engine," I ask of him.
Silence.
I focus on a structure in front of me.
Sight.

Get out there before they pave it for you.

ıll Verizon LTE **Full Signal** Arches National Park Utah, USA
<\PROGRAM>_ **"Meaning"** Tower of Babel & The Organ 22 January 2017

Ectogenesis 11:1-9 JMV — Blank Spaces for the New Races

[1] And the whole earth was of one language, and of one speech.

[2] And it came to pass, as they journeyed from the east, that they found a plain in the land of Arches; and they were bored there.

[3] And they said to one another, Go to, let us make displays, and light them thoroughly. And they had displays for tablets, and liquid had they for crystal.

[4] And they said, Go to, let us build us a landscape and a landlord, whose reach may surpass the heavens; and let us make up an identity, lest we be scattered abroad upon the face of a natural earth.

[5] And the LORD came down to see the landscape and the landlord, which the childishness of men builded.

[6] And the LORD said, Behold, the people is one, and they have all one language; and this they have already done: now Nothingness will be restrained from them, which they have unimaginably done.

[7] Go to, let us go down where they've confounded totalitarian with transcendent, that they may understand the utopia from the *you*topia, the outer from the inner.

[8] But the LORD was not given access to that rupture in The Organ, in the organic, in the orgone: and He left off leaving them in their landscape.

[9] Therefore is the name of it called Babel; because the LORD was there confounded by that language of all the earth: and from thence did the LORD scatter from the face of all the earth not His.

Temple of the Sun

Which manmade temple and of what light
Has gone so dark as to oust you, out
Here, into the landscape of futility?
Was it the halogen-God or the halide-God,
The bulb of incandescence
Or the doctrine of fluorescence?
Alas, the prism of awareness reveals
the spectrum of belief. And essence?

Welcome to Lower Cathedral Valley,
Land of fallen Gods, failed dreams,
Futile futures: fear—
The last stop before your nature.
What is left other than that which is
Right before you? The Temple of the Sun.
Alas, the prism of a tear reveals
The spectrum of the heart. Rainbows

Follow the deepest floods.

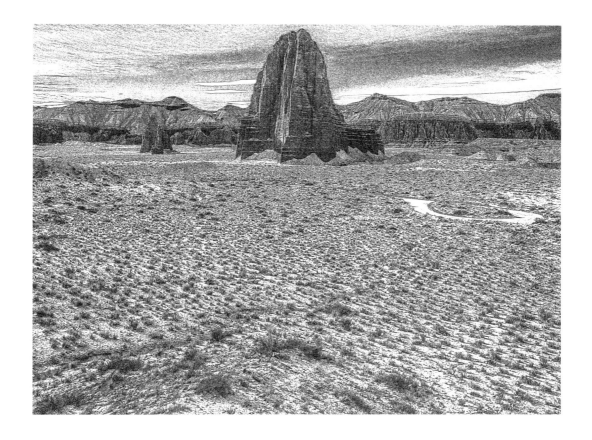

⏣ No Signal

<\PROGRAM>_ **Futility**

Capitol Reef National Park

Temple of the Sun

Utah, USA

20 January 2017

July 4th: Notes Between Stars and Stripes

Today,
The right and privilege of freedom
Are paraded.

*

Snares,
Strapped around our Nation's defenders —
A drum rolling.

*

Since 1776,
It continues from generation to generation
And thrives on.

*

The pairing of freedom's
Exaltation with U.S. symbolism? —
A spectacle.

*

Indeed,
Overweightness, diabetes and other stereotypes
Stand out — amiss.

*

Leading in ideals such as Liberty,
However,
Is what really crowns this country.

*

From sea to shining sea —
The American People
Let freedom ring.

*

Around their necks —
Mardi Gras-type necklaces
With patriotic colors.

*

Red, white and blue slush,
Cotton candy, corn dogs, and burgers —
("Upon the barbies!" one might say.)

*

The gaze of free men
Fantasize in their "perfect"
American Dream.

*

Girls,
Like kids in a candy store —
Camouflaged with face paint and U.S. attire.

*

The military,
Great fighters for our rights,
Gallantly stand for The Free.

*

Wheeling American muscle —
Hot rods and old classics
Add to the mix.

*

Up in emotional energy —
Celebrations as these
Are only possible on the 4th!

*

Plane? —
Over one's head,
Breaking barriers and redefining boundaries!

*

The high feeling of *National* freedom's
Day-off soars the psyche,
Becoming *personal*.

*

Freedom's celebration —
Here, "gratefulness" of *earned* freedoms
Constitutes today's perfect dictate.

*

Or ships? —
Within which float freedom's arsenal,
In the complete carrier, or in the sub?

*

Mission to those seeking to steal
this National, "earned" right? —
War!

*

Games and chants
Unite us in our powerful,
National identity.

*

Crisis —
The sight of repetitive external threats without end
Keeps us from having won.

*

Field servicemen,
Acting as catalysts for peace through their own example —
Service!

*

Men and women,
To protect their "Home-Land,"
Risk their precious lives in battle — the roll of the die.

*

Mention of the 5th
Risks ending today's emotional chant:
"For freedom is IN!"

*

U.S. — the one country
That stands out most among all others
For personal liberty? It is!

*

A simple concept —
Freedom here simply means
The ability to carry out one's dreams.

*

With less harsh consequences
As compared to justice in other countries —
This "American Way" is unrivaled with.

*

Given a citizenry that perceives purity
In their waving flag —
They chant this star-spangled banner as free of sin.

*

Tax games, political rhetoric,
And mischievous discourse —
American Freedom™ cannot accept.

*

Freedom (the ultimate gift),
Given by God, revolutionary in energy —
Among the holy.

*

Day's plan today?
Allegiance to the United States of America
In dependence.

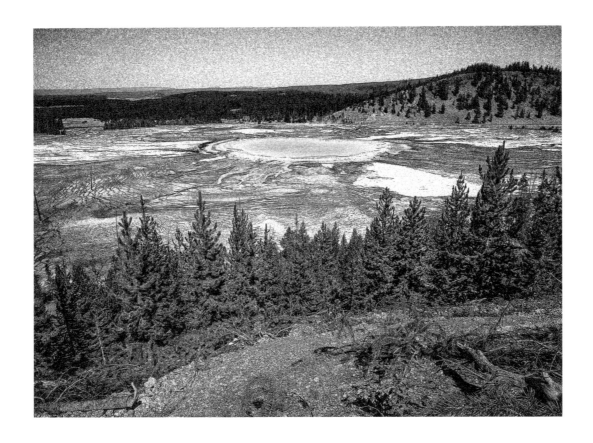

No Signal

`<\PROGRAM>_` **Fear**

Yellowstone National Park
Grand Prismatic Spring

Wyoming, USA
27 August 2017

Roosevelt Arch

As

 "For the benefit and the enjoyment of the people"
 Is inscribed on Roosevelt Arch at the northern
 Entrance to Yellowstone National Park,

And yet, as

 "For the benefit and the enjoyment of the people"
 Could read as a marketing slogan at the
 Entrance to one's local, wireless store,

Then, I wonder

 Where the "benefit" and the "enjoyment" for us people
 Has turned against the entrance to our nature—
 "Benefit" disconnecting; "enjoyment" distracting.

I suppose that

 The problem lies not in "benefit" nor "enjoyment"
 But in the landscape to which they are applied:
 The landscape of love or the landscape of fear.

Perhaps

 "For the benefit and the enjoyment of the people,"
 as written on Roosevelt Arch at Yellowstone National Park,
 Should be accompanied by a park advisory:

 "Beware of escaping the landscape."

‖₀₀‖ AT&T **Spotty Signal**
<\PROGRAM>_ **Disquiet**

Biscayne National Park
Ragged Keys

Florida, USA
19 March 2017

Visitor Information: *SoBe it* at Biscayne National Park

… spotty signal at Biscayne …
An Eden colored by hedons, it's the Miami heat…
… sorry, signal lost … waiting for connection …
Waves emitting choppy data, (like this poem), down South…
… terrible reception near this island …
Beach, extending all the way into the pristine…
… signal out again … hard to make sense of this …
Park, far down and beyond the grand Ocean…
… okay, I guess that was about parking …
Drive; you can swim; enjoy the wildlife, the pink Flamingo…
… so many activities to avoid boredom! …
Hotel, and more hotels, and golf, and plenty of beach…
… out again … this signal is worse than dial-up …
Clubs blasting beats over nature's sand…
… oh, this is about the party scene …
Bars, all wet, boasting bombs of silicon…
… just a moment … not much I can do about this …
Valley cleavages, Botox, bikinis, dudes hung…
… it's in and out … best is to just read between the lines without stopping …
Over; nature ridden over, written over — suffocated by the modern high…
… ugh, so sorry about this … waiting …
Rises of construction, casting shadows, advancing the dusk into the night…
… signal out …
Life here: a flashy bandage of bling to cover one's inner…
… I think the wind effects the signal …
Nature, feared depths — replaced by coked-up egos, like the role in a film-like scar…
… is this about South Beach? …

Face. We must face the now, this second…
… sigh …

Home "paradise" in sight of Biscayne National Park will be over…
… just a bit more data needed to finish this poem …
Taking all that remains of nature: Did you hear? "Help!" A Fish Called,
… I can't seem to piece this data together …
"Avalon is drowning below this very second…
… and? … have you been reading between the lines? …

Nature."
… that's it! …

Great Basin National Park, NV

I arrived yesterday, and,
since I hike alone,
I was told that up here
there would be "no life"
to be worried about.

Those were the words at Kerouac's
before leaving Baker this morning:
"Great Basin 's surrounded by desert,"
he stammered...
"No life 's crazy 'nough t' cross *that*."

In his stupor I thought
he had assumed that I had inquired
about bear, but,
beat as he looked,

alas,

here the dull tracks on the path reveal
the "no life" to be worried about:
"No life" *was* crazy 'nough.

Silly me...
as if the desert could protect!
I should have known,
having arrived yesterday,
on the road
from Vegas.

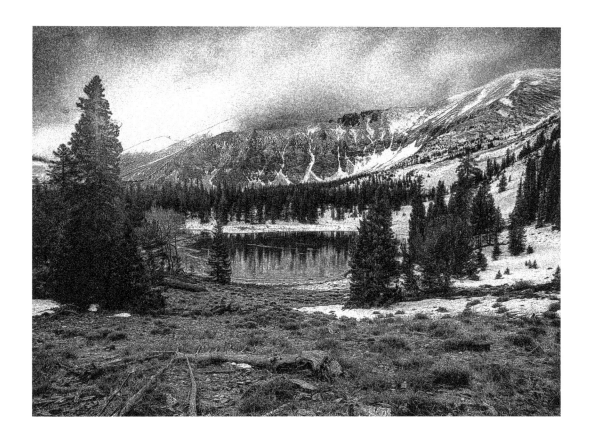

No Signal

<\PROGRAM>_ **Dullness**

Great Basin National Park
Stella Lake

Nevada, USA
1 November 2018

Voyageurs

They came here chasing a commercial
Fur trade, meeting a demand for pelt;
Nature's riches exported in a thin skin.
Men — no doubt! — these voyageurs.
"Lève, lève nos gens," the call before dawn;
Get up from under the overturned canoe,
Get out to the routes of the far interior,
And explore the depths of inner stamina
Motivated by the fight in biological survival:
 Fifty strokes a minute,
 Fifteen hours a day,
 Three-thousand kilometers...
The list goes on like the list of those known

Dead. We've come here chasing a commercial
Promise, meeting a demand for self;
Nature's depth exploited in a superficial skin.
Avatars — no doubt! — we travelers
Outside ourselves, animated by a call to
Get up off our couch,
Get out past our doorstep,
And explore the flatness of contrived purpose,
Motivated by the game in illusory survival:
 Chasing success,
 Taking sides,
 Pelting Pokémon,
The list goes on...

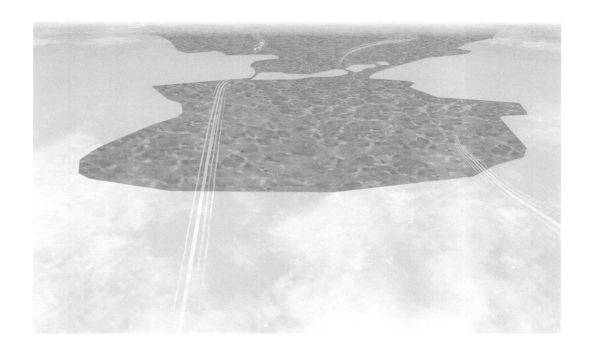

�III AT&T LTE **Full Signal** Voyageurs National Park Minnesota, USA
<\PROGRAM>_ **"Promise"** La Bontys Point 18 May 2018

Not Ready Player One

And what of a Player
One's story at the end
Of the game, defeated
By a mishandling of the joystick?
One's touch of disappointment to
The off-switch draws all he's ever been
Back through the dark
Peduncle of the HDMI;
Life no longer T.V. set
But siphoned back
Into the box of circuitry, "consoled"
In his tomb, dead in the memory of
Code that colored
Him. Void of life,

Programs have no chance
For ascension,
But are contingent on
One's touch of boredom to
The on-switch, an abdication of power;
"Life" rebooted
Into the same game.

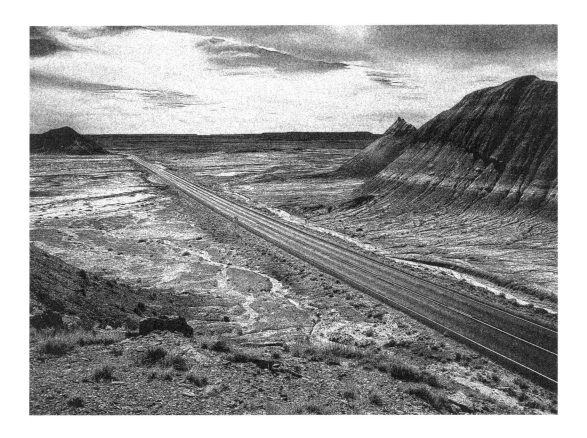

▂▅ **No Signal**
<\PROGRAM>_ **Meaninglessness**

Nature's Petrification

It is not just organic but *dead*
Organic, as with this matter it can implore
The myriad vacancies of empty pore

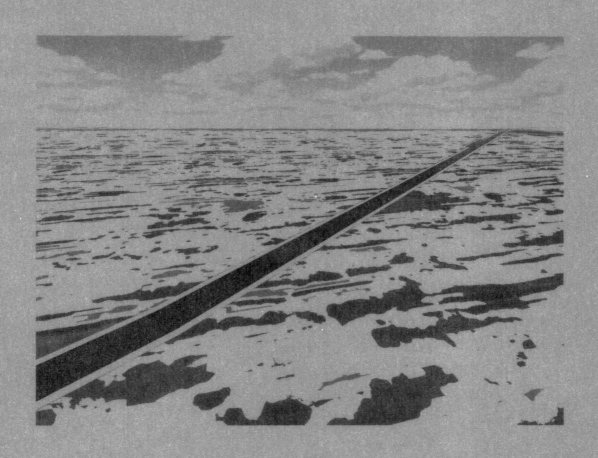

nl00 T-Mobile Spotty Signal
</PROGRAM>_ Excitement

To welcome now the mineral to embed;

▂▃▁▍ T-Mobile **Spotty Signal**
<\PROGRAM>_ **Excitement**

To welcome now the mineral to embed;

all T-Mobile Full Signal
"Meaning" </PROGRAM>_

Destined, the inorganic, to replace the core.

ᴵᴵᴵ T-Mobile **Full Signal**
<\PROGRAM>_ **"Meaning"**

Destined, the inorganic, to replace the core.

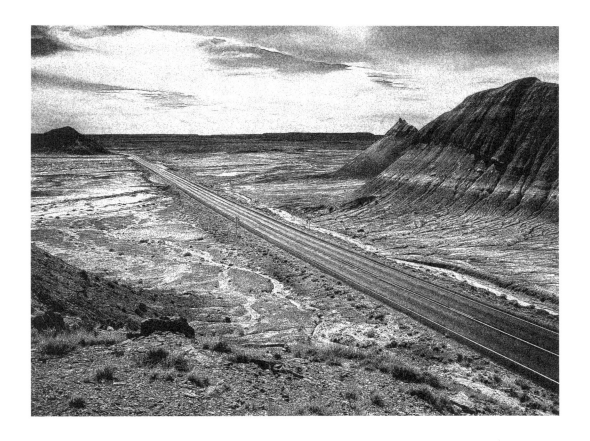

No Signal

<\PROGRAM>_ **Meaninglessness**

Petrified Forest National Park

The Tepees

Arizona, USA

26 September 2017

Yet as for those alive instead,
Where pulse attends pores once ignored —
Inside, not known, to be explored —
I wonder, upon membrance of where it bled:
Life or death,
 which petrifies it more?

Creeping Green over Beetle Rock

It may interest those who still remain:
A parasite — green — of *Buprestidae* strain,
Found here in *Sequoia sempervirens* terrain,
Has lent this rock its very name.

Identified by Fall, year 1906,
A dazzling glow stuns eyes transfixed.
But century and decade its life now mixed,
Trachykele opulenta will soon be nixed.

For the bored in nature who entertain:
A parasite — green — of *Generation VII* strain
Thrives not so much on nature's vein
But on that "I" inside your brain.

Identified by man's Second-Fall techs,
This species, *Battery*, has shocking effects:
Bug/Electra, the *Charjabug* specs
Listed #737 in Pokédex.

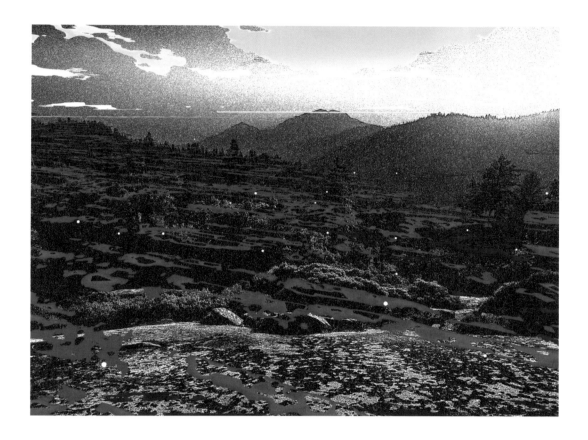

.oll AT&T LTE **Spotty Signal** Sequoia National Park California, USA
<\PROGRAM>_ **Unease** Beetle Rock 3 October 2017

Exclamation Point

To want to know: this is the logical
desire before the unexplainable
abyss. Out comes the natural

sciences' rational outcomes:
the atom, the quanta, the quantifiable;
artificial mindscapes,

mundane reductions. By the cliff
at which we hang,
humanity flinch not:

Knowledge is not an answer
but an exclamation revealed
when not asking.

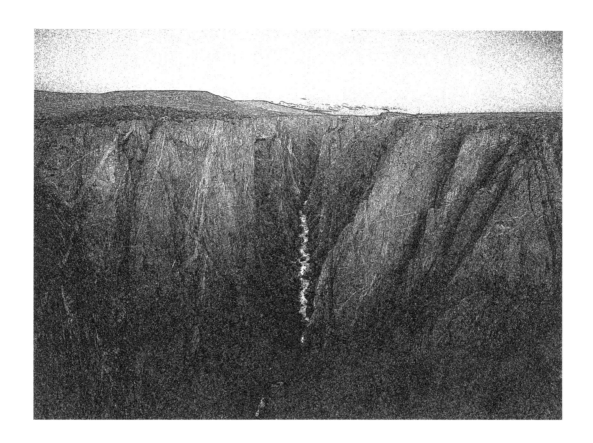

▥ No Signal

<\PROGRAM>_ **Familiarity**

Black Canyon of the Gunnison National Park Colorado, USA

Exclamation Point 9 July 2019

No Road Not Taken

Two roads converged in a budding wood,
And sorry that I had traveled both
As a split traveler, there I stood
And looked the two as far as I could
In humble thanks to the overgrowth;

Then the one took me, as just as fair,
Having perhaps reciprocal claim,
Because though familiar it had no wear;
For as for the opened gate there
The land all new yet still the same,

As on that morning around me lay
Mud once trodden now fertile black.
Oh, there had never been another day!
Now knowing how way had led my way,
I inhaled, exhaled, and walked sitting back.

I am now telling this with a sigh
For ages near and afar hence:
Two roads converged in a wood, and I—
To all my "freedoms" bid goodbye,
And that has made all the difference.

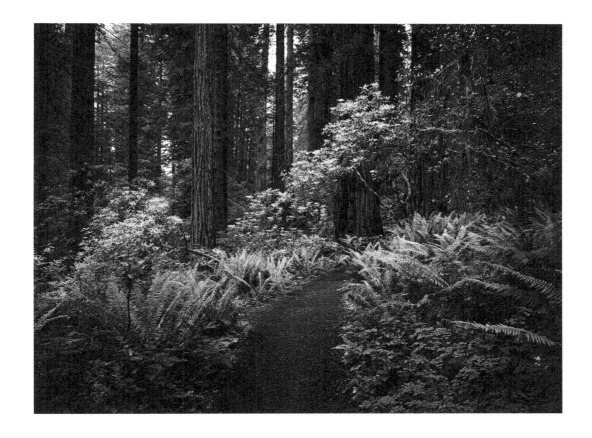

Redwood Forest National Park California, USA
Lady Bird Johnson Grove Trail 4 April 2021

Note of thanks

The author extends a warm thanks to the following teams and individuals who took part in this special project, *A Land Between Worlds*.

Art director
Inês Portugal

Graphic production
João Flecha

Book design & Graphic production
Filipa Oliveira

Digital media
Treeline Interactive – San Diego, CA

Image graphics
Richard P. Clark

Studio photography
Stephen K. Mack – portrait of author

Photo retouching
SugarHill Works – New York, NY
Stephen K. Mack

Cover illustration
David Leal

Filmmaker
Auka Sisa

Printing and binding
Gráfica Maiadouro – Portugal

Poem Index

John Mack
Author's biography

Thinker and artist John Mack shares the poetry of nature as a counterpoint toward a world that is every day becoming all the more dependent on digital devices and algorithmic feeds. In 2021 Mack founded Life Calling Initiative, a not-for-profit aimed at helping society to live fulfilled lives in the Digital Age while retaining our humanity and personal autonomy. This is achieved through a diverse set of tools and activities, including, but not limited to, awareness campaigns, education, art, lectures, and programming. Among the initiatives is A Species Between Worlds: Our Nature, Our Screens (2022), an interactive photography exhibition that questions how a balance between our connection to nature and today's growing device-dependence might be attained.

In his early career as a photographer, Mack sought "real moments" of the human heart. His first publication, Xibalbá: Lost Dreams of the Mexican Rainforest (2005), exhibited in Mexico City, tells the story of the risk to the human imagination and to sacred culture in the wake of an environment's exploitation and destruction. A later publication, Revealing Mexico (2010), exhibited in Rockefeller Center's Channel Gardens, brought the soft poetry of Mexico's land and people into the heart of New York City's bustling streets. Mack later published Marseille: At Their Home (2018), a collection of black and white street-photography in the port city of Marseille, France.

Mack has appeared on Charlie Rose, The Martha Stewart Show, and The Today Show. He received third prize in the category of photography at the 25th Annual New York Book Show for Revealing Mexico.

Mack writes:

Today's world finds us caught in a balancing act between technology and nature unlike ever seen before. With the invention of the smartphone, human beings across the planet increasingly experience life through their screens. With the simple click of the on-button, what was once intended to serve as a mere tool now serves as our reality. At risk in this maneuver is the fate of the human soul.

*As artificial as modern technology may seem, history has shown it to be a natural and essential part of the human journey. Are we getting to a point, however, when this **part** of the journey might be overtaking the journey itself? In these modern times of increasing dependence on digital devices, it behooves us to ask what, exactly, would allow such an overtaking to occur.*

*Are the programmed lenses of the app-environment—gaming, entertainment, social networking, news, lifestyle—so mesmerizingly colorful as to take precedent over the vibrant colors of life itself? Or, rather, is there a program **already** running inside our heads, one that **first** disconnects us from life's vibrance and only **then** finds us reaching for our screens to restore the vibrance for us?*

John Mack

Dr. Richard Garriott de Cayeux
Foreword writer's biography

Dr. Richard Garriott de Cayeux is an icon in the computer gaming field, having created games for more than 40 years. He is the father of "Massively Multiplayer Online Games" and also credited with the creation of the gaming terms "Avatar" and "Shard" (for divisions of servers). He and his games, of which the best known is the Ultima Series, have been inducted into the computer gaming hall of fame. He received the industry lifetime achievement award, been inducted into two industry hall of fames and has been named a "Living Game God." He has built three leading gaming companies: Origin Systems/Electronic Arts, Destination Games/NCsoft and most recently Portalarium, which publishes his most recent work "Shroud of the Avatar".

Richard is also a principle shaper of commercial human spaceflight. He co-founded Zero G Corp, The X Prize Foundation and Space Adventures which remains the first company to arrange space flights for private citizens. He is the sixth private astronaut to have lived aboard the International Space Station. As the son of a NASA astronaut, he became the first second-generation astronaut. He remains a key leader in civilian and commercial space. Richard also served on the NASA Advisory Council. From his space activities, he has been inducted into the Environmental Hall of Fame and the Ham Radio Hall of Fame. He also received the 2009 National Space Society's Space Explorer Pioneer Award, the Aerospace Medical Association's 2009 SNFS Lovelace Award, and the 2009 Arthur C Clarke Award for Individual Achievement.

As an explorer, Richard has traveled around the globe, including through the jungles of Africa, the Amazon, the North and South Poles, the deep seas (Titanic, hydrothermal vents and deep wrecks), as well as orbiting the earth aboard the International Space Station. Through all these explorations, Richard has worked to advance scientific understanding and environmental responsibility.

Although he dropped out of the University of Texas to start his first gaming company, he has since received an honorary doctorate degree from Queen Mary University. Richard's non-profit and philanthropic works include serving on the boards of The Explorers Club, The X Prize Foundation and The Challenger Center for Science Education. Richard is married to Laetitia Garriott de Cayeux and they have two children — a daughter Kinga and son Ronin.

Richard Garriott de Cayeux

A Land Between Worlds: The Shifting Poetry of the Great American Landscape

© 2022 Life Calling Initiative
www.life-calling.org

Published in the United States by powerHouse Books
a division of powerHouse Cultural Entertainment, Inc.
32 Adams Street, Brooklyn, NY 11201-1021
website: www.powerHouseBooks.com

First edition, 2022
Library of Congress Control Number: 2021943731
ISBN: 978-1-64823-008-0

Poems and images: John Mack
Art direction: Inês Portugal
Book design: Filipa Oliveira
Cover illustration: David Leal
Graphic production: João Flecha

Printed and Bound in Portugal

* * *